THIS FASHION FAIRY TALE

BELONGS TO

PRINCESS _____

WHOSE ____ YEARS

OF DREAMING

WILL BE REWARDED

WITH HIGH HEELS

AND HAPPY ENDINGS

MANOLO BLAHNÍK AND THE TALE OF

the Elves and the Shoemaker

a fashion fairy tale memoir

MANOLO BLAHNÍK

AND THE TALE OF

the Elves and the Shoemaker

CAMILLA MORTON

ILLUSTRATED BY MANOLO BLAHNÍK

itbooks

AN IMPRINT OF HARPERCOLLINS PUBLISHERS

TO ALL OUR FRIENDS. . .
AND TO OUR MOTHERS

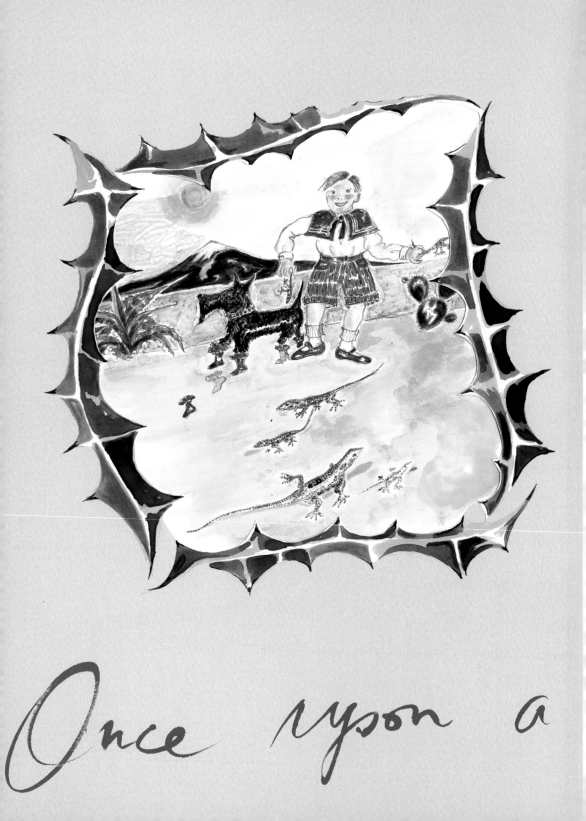

Once upon a

Once upon a time, there was a lizard, a dog, and all manner of lively animal friends, who wore shoes . . . and not just any shoes, but *magical* shoes. These magnificent slippers were twisted from Cadbury chocolate candy foils and sweet, shining bonbon wrappers . . . They had all been made for the colorful menagerie by a very special little boy with an eye to delight and a mind to create whimsy all around him.

THAT LITTLE BOY
WAS NAMED

MANOLO BLAHNÍK.

Our story begins on one of the smallest, most far-flung of all the Canary Isles, a mere dot if you look on a map.

IT WAS HERE
THAT OUR HERO
WAS BORN.

Young Manolo was schooled on the family banana plantation and spent an idyllic childhood growing up amongst the jungle leaves and the warm summer sun with his younger sister and parents as his happy playmates and companions.

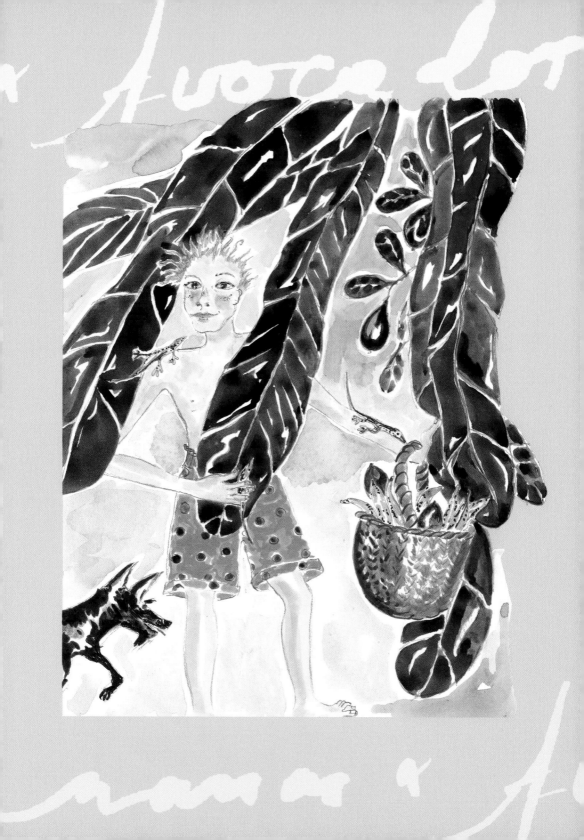

Here on their island, no animal, beast, or passing object was safe from Manolo's creative touch, and he could often be found deep in the wilds of his own make-believe world, blissfully sketching and shaping new ideas and adventures for them all.

HE WAS BROUGHT
UP WITHOUT THE SMOG
AND DISTRACTION
OF CITY LIFE,

on a diet that nurtured his creative soul with books, piano lessons, and trips to the cinema.

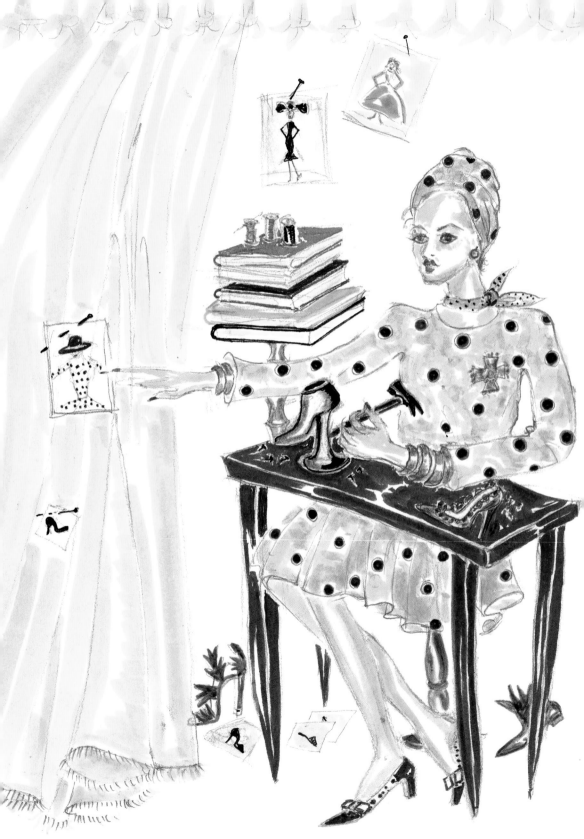

One of his greatest inspirations was his mother, a beautiful woman with an eye for fashion. She would study magazines brought in from near and far, so she could explain to the local seamstresses how best to interpret these ideas. Soon, she, too, was wearing the latest styles.

ONE THING, HOWEVER, THAT ALWAYS LET HER DOWN WAS THE CHOICE OF SHOES.

Or lack thereof. Wartime restrictions meant that the loveliest ones she dreamt of rarely made it as far as their island. So, being a woman of character, she took matters into her own hands, quite literally. The local cobbler taught her the rudiments of his craft, provided the soles, and from there she created the rest.

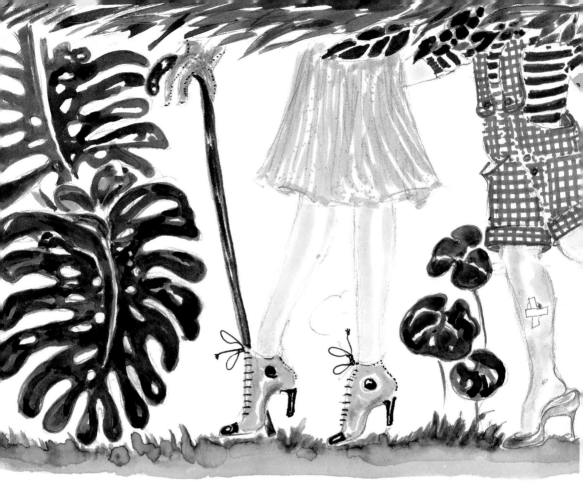

Manolo would watch in rapt fascination as his elegant mother would
hammer every fabric she could find into new shoes and daring
styles. Each pair she made would mirror and often improve upon
all the others they saw posed and proudly photographed in the most
glamorous of American fashion magazines.

Walking with my mom

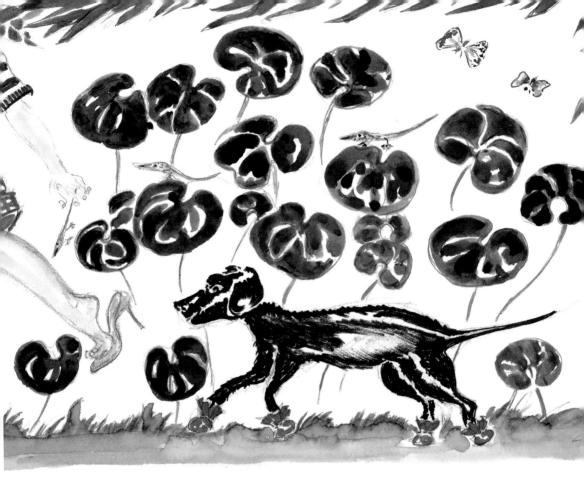

OF ONE THING HE WAS QUITE CERTAIN: THIS WAS PARADISE.

Here was a land of harmony and happiness, where imagination could run riot. Every flower, leaf, butterfly, and color caught the young boy's eye, luring him to fill sketchbooks and tempting his every dream with fantastical creations of his own.

forbidden High heels & Romello

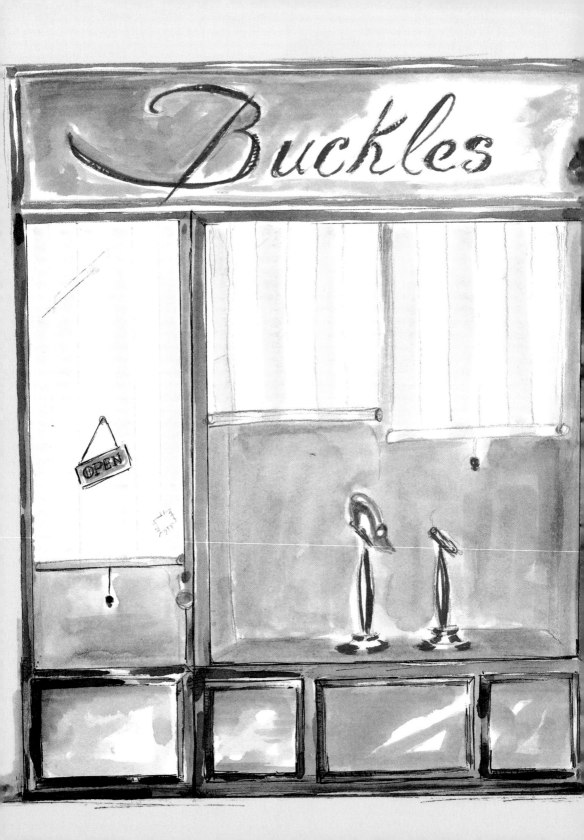

But there are always two sides to every coin, and, over in a land seemingly a million miles away from the bliss of Manolo's existence, lived Mr. and Mrs. Buckle, an elderly shoemaker and his wife.

WHILE YOUNG MANOLO HAD SUNSHINE, THEY HAD NOTHING BUT CLOUDS.

While he had fanciful ideas, they, regrettably, had none. While he enjoyed the carefree innocence of childhood, alas, all of that seemed a very long time ago to them. They had *so* many bills to pay now all they could do was worry. Despite their best efforts and constant prudence, they were very, very poor. The Buckles were terribly down on their luck and didn't know how they could possibly break the cycle. But as bad as things were, they remained a devoted, kind, honest, and hardworking couple, and for that they counted their blessings.

11

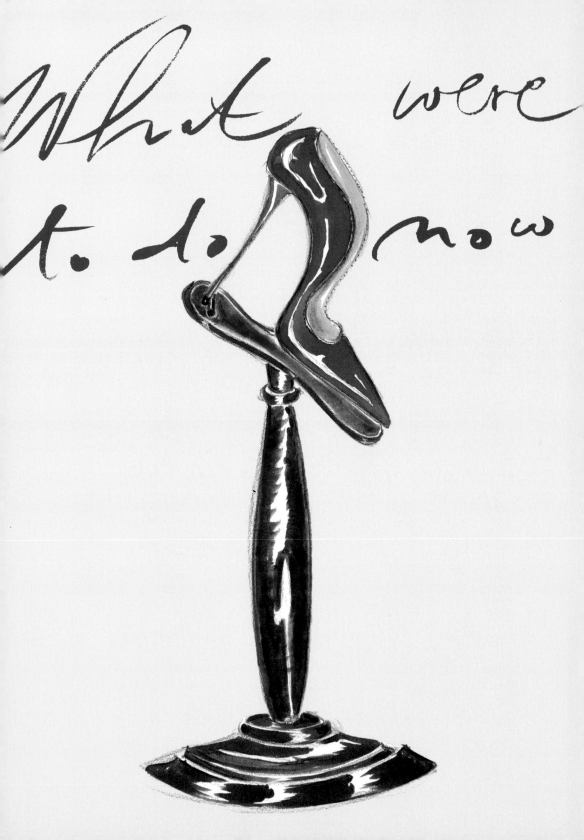

they going ?

In the Canaries, the sun shone as brightly as the little boy's sparkling charm, but in Mr. and Mrs. Buckles' world, the future looked bleak. They had no family around them, customers were dwindling, and no new apprentices were coming into the studio to learn their skill and work with them. This lovely couple had long fallen out of step with the fast-paced changes in their trade.

Just as things couldn't get any worse, of course, they did.

THE DAY THEY DREADED HAD FINALLY DAWNED:

The Buckles were down to their last piece of leather. This meant that there was only enough for one final pair of shoes. After that—who knew what would happen . . .

Carefully, the old shoemaker thought up a style, cut and scored the leather, and fashioned it on one of their old wooden lasts. Wistfully, he thought of his father, and his father's father, and his father's father's father before him—all great shoe-making men of generations past. Then he thought about his and Mrs. Buckle's son. They had not spoken in years, as the boy had refused to follow Mr. Buckle into the family business.

HOW COULD THEY HAVE A CHILD WHO WAS NOT A GREAT SHOEMAKER?

All of this had proven to be a double blow. Since his son had left, so, too, had Mr. Buckle's drive and inspiration, and, indeed, his wife's cheery smile. The legacy of a once-thriving family business haunted him every day. He had failed to pass this time-honored craft on to the next in line, and it appeared as if they would soon be arriving at the end of the line . . .

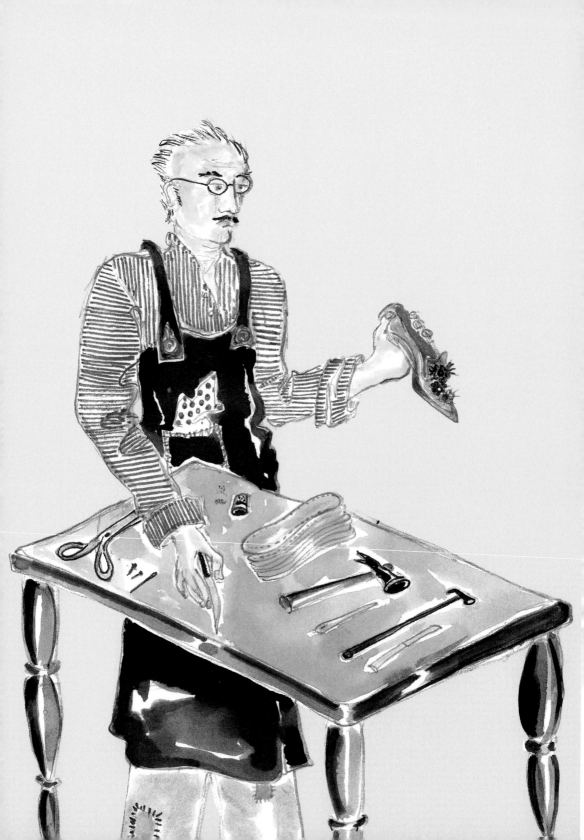

What were they going to do now? There was no money to buy new leather . . . and without leather they could not make new boots or shoes . . . and without new boots or shoes they had no way of earning enough money to keep a roof over their heads. It was a vicious circle. Mr. and Mrs. Buckle were weary with worry.

THEY HAD NO SKILLS OTHER THAN SHOE-MAKING AND NO ONE TO COME TO THEIR AID.

Silently, Mr. Buckle wiped a lone tear, which stole from his eye, with his red-polka-dot handkerchief. This was a sorry state of affairs indeed. But no, he was not going to give up. Tomorrow was another day; something would help him turn things around. All he needed to do was hope. Just not tonight. Right now he was far too exhausted to do *anything,* let alone stitch with the precision his last handcrafted pair of shoes deserved. He sighed. Then the old shoemaker slowly laid out his tools for the last time, neatly lining them up alongside the leather on his workbench. He would be ready for the morning.

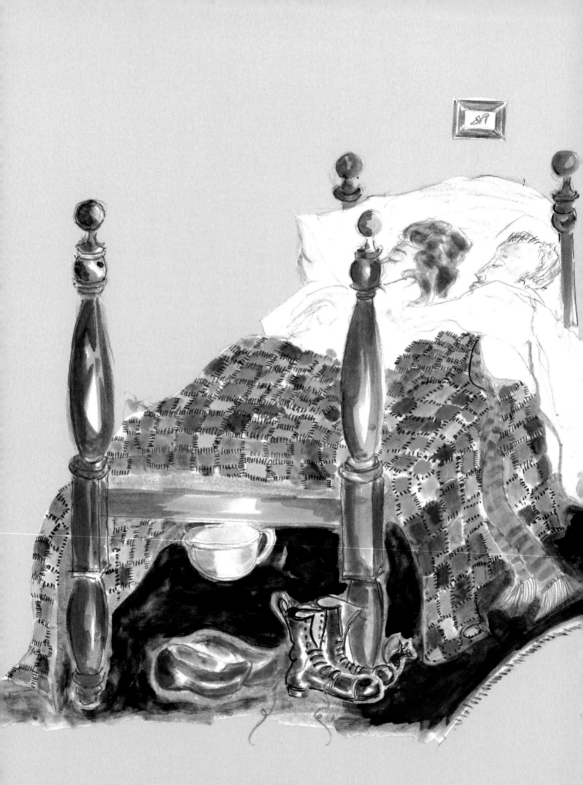

Mrs. Buckle was a devoted wife, who hated to see her husband so beaten and lost. She had been watching him quietly, as she always did, through the slight crack in the door. As he laid down the last tool, she summoned all her cheer in a deep breath, knocked loudly with her clog, then, without waiting, bustled her way into the room, carrying with her a warm cup of tea.

It broke her heart to see her Mr. Buckle so defeated. She smiled her brightest smile and tried to nod encouragingly as he described what he would make with the last piece of leather. Then, after a while,

THEY CAREFULLY BLEW OUT ALL THE CANDLES IN THE FORLORN STUDIO AND READIED THEMSELVES FOR BED.

Mr. Buckle took Mrs. Buckle's hand in his and sighed. "This, my love, is the last pair of shoes we can make. Who knows what will happen to us after that. We have to plan for the worst . . . I'm afraid I have let you down."

"Nonsense, dear," his wife gently scolded, though it did look to her as if it was going to be a sorry ending for them, after all.

19

The plight of the couple became legendary and was even the subject of a book. It didn't matter what age Manolo was, he always hated this chapter of the story. How heartbreaking it was.

HE WOULD SNAP THE COVER SHUT AND WISH FOR THESE GENTLE PEOPLE TO BE IN VERY DIFFERENT CIRCUMSTANCES.

He really couldn't bear to see the sadness on the shoemaker's face, or, indeed, imagine a place where there was no more care for creativity. It was all too impossible. If only someone could help the kindly couple . . .

As Manolo grew, his attentions were diverted, and soon enough he was off to University. He went to live amongst the mountains and the rivers of enlightenment with his aunt and uncle, and just as his studies influenced him, so did these remarkable relations.

UNDER HIS AUNT'S TUTELAGE, HE REFINED HIS TASTES AND LEARNT TO APPRECIATE THE BEAUTY OF LUXURY, ART, AND, OF COURSE, HAPPINESS—

the definition of which, according to her, was having the single most elegant handbag ever made, in every color available!

His aunt was a lady with an impeccable eye for detail, color, and content, and soon Manolo was schooled in the same. It was only a matter of time before his law books were swapped for those in literature, languages, and fine art. Manolo thrived amidst such rich culture. In fact, the more he learnt, the more he hungered.

Soon it was time for the boy from the small island to set off in search of even bigger adventures . . .

HE MOVED FIRST TO THE CITY OF LIGHT, AND THEN TO THE CITY OF OPPORTUNITY,

where, at last, it was time for his journey of discovery to build to a crescendo.

This new, cosmopolitan town was worlds apart from his sheltered secret island, but soon he was head over heels and immersed in all its exuberant "madness." London, with its vibrant swinging nightlife, was not at all as gentrified as his studies had led him to believe. Books had conjured up a much more solemn place in his mind. His experience of it was far more real, raw, and gloriously colorful.

THIS CITY WAS LIKE NO OTHER PLACE IN THE WORLD,

attracting both the extraordinary and the extroverted, and Manolo took to it like a duck to water!

Whatever the event, location, or party, Manolo was always drawn to the cleverest, most beautiful, and most luminous characters. He had found kindred spirits and his soul reveled in this hazy excitement.

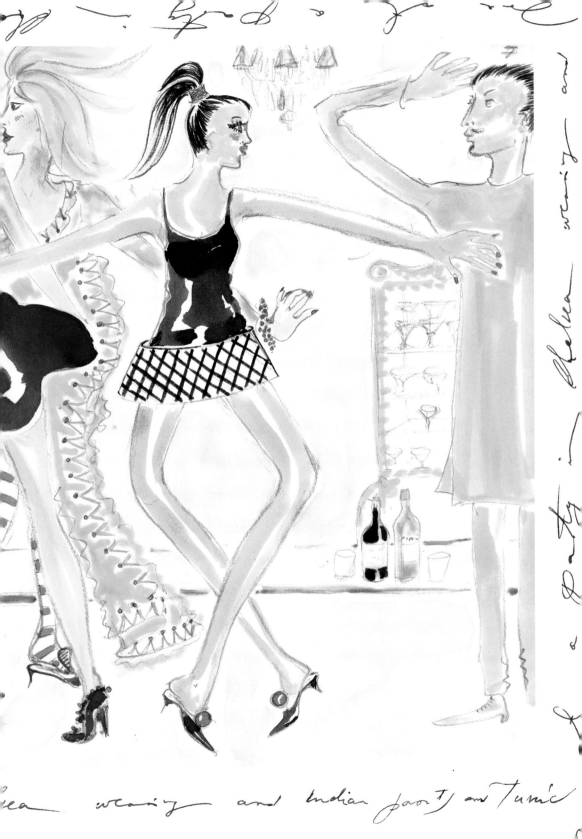

To celebrate his debut on the scene, Manolo cast off his gentleman's gray garb and bought a flame-red wool waistcoat, secured a job at Swans—the most fashionable boutique in town—and flitted like a moth to the flames sparking off his like-minded friends. As he loved them, so they loved him, and Manolo was soon a firm favorite on London's heady art scene. He was the dandy, the gentleman, and, thanks to his upbringing, the always impeccably dressed and pressed likeness of his heroes, the matinee idols.

This dapper young man was indeed living very much like his very own idol—Cecil Beaton—in both manner and magic; so

IT WAS ONLY NATURAL THAT HE SOON BEGAN LONGING FOR A CAREER IN THEATRE OR FILM AS A SET DESIGNER.

What else could be nearly as electrifying and exciting?! He etched and sketched, doodled and drew, and showed idea after idea to all his friends—his energy was boundless. *But how best to channel this enthusiasm?*

th Romy Schneider a Alain Delon th
me the perfection of beauty. Sub

Racine

this moment with Schneider, Delon

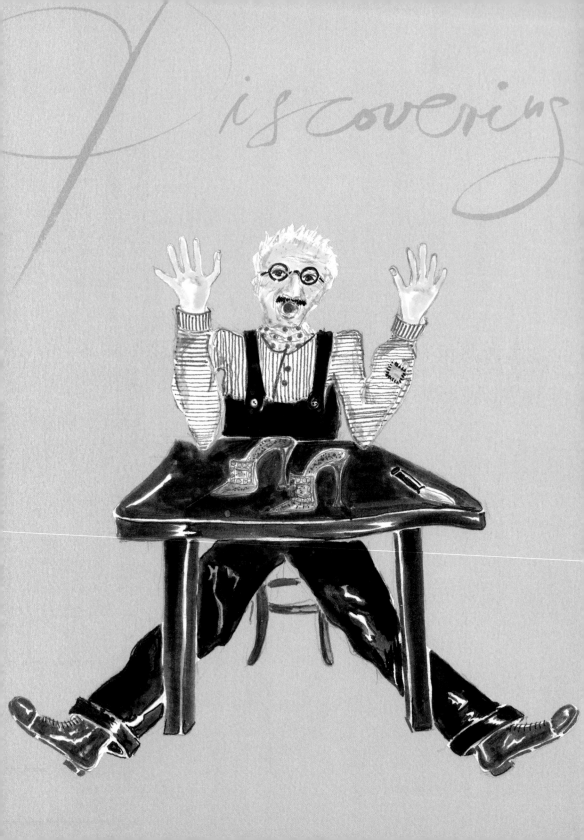

Discovering

the new shoes

Enthusiasm, however, was not what the old shoemaker felt when he awoke the next morning. He slipped quietly down to his studio before his wife arose, so he could complete his all-important final task without worrying her any more than she had already been worried. Everything hung on this last pair of shoes.

Well, you can imagine his surprise when there, as he approached his bench, he found the most beautiful pair already crafted!

THESE SHOES WERE FAR LOVELIER THAN ANY HE HAD EVER SEEN—LET ALONE MADE—BEFORE.

They had been scored and stitched together with a virtuoso's delicate skill. Whoever's nimble fingers touched his humble creation had transformed it beyond his wildest imagination. The old shoemaker was astonished, and scratched his head in wonder as he examined each shoe from heel to toe. It was too good to be true.

Mr. Buckle ran to his wife. "Look! Look!" he cried. "You won't believe this—look at these shoes! Aren't they beautiful? Aren't they perfect? What a style! What an idea! But *who* could have possibly helped us?"

His wife was equally stunned, and agreed that this really was the most perfect pair of shoes she had ever laid eyes on. There was not one stitch out of place. The brocade, the heel, every element was more exquisite than the next.

THE HAPPY COUPLE MARVELED AT THEIR UNEXPECTED GOOD FORTUNE.

Mrs. Buckle, who had always been a sensible woman, picked up the shoes, placed them on a red velvet cushion, and positioned them proudly in the center of their shop window. She added, in her neat, curling handwriting, a tag that read:

For Sale

Now everyone could admire this beautiful handiwork . . .

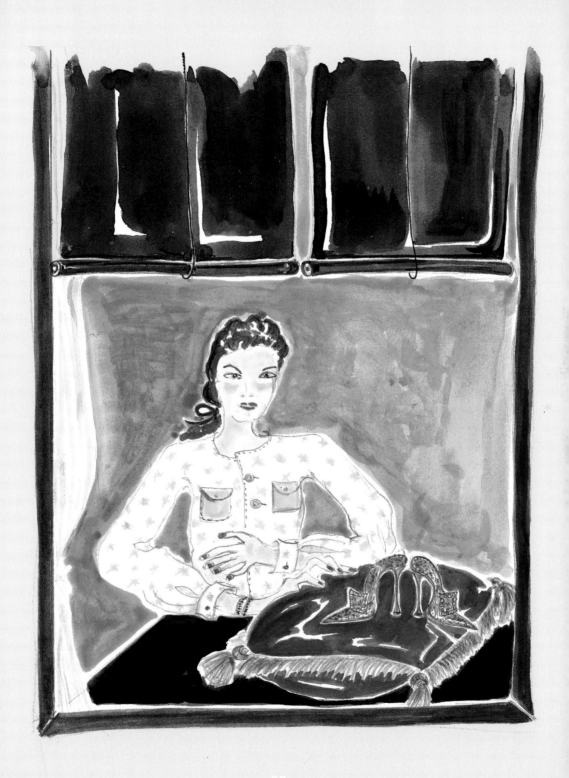

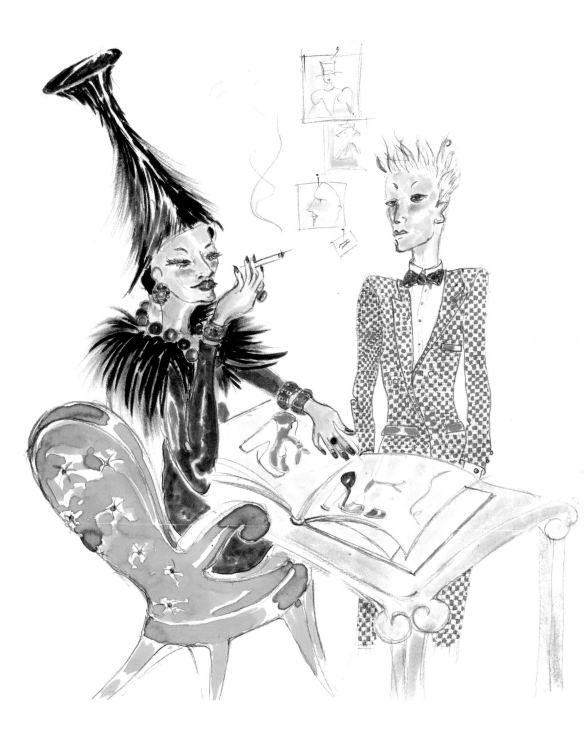

As Mrs. Buckle turned the sign on the door of the shop to

Open

Manolo nervously straightened his tie and stepped forward into
the lobby of the building where the glossiest magazine in all the
world was created each month. He had managed to secure an
audience with its legendary Editor,

THE ULTIMATE EMPRESS
OF STYLE AND CHIC,

though today, as he nervously tried to flatten his unruly hair, he felt
like a small child presenting his shell collection to a Glittering Great
Queen. But if anyone could advise him on how to get into set design,
or indeed what avenues were possible for him, it was she. His fate
was resting on a portfolio tied together not with ribbons but rather
with heartstrings and all his soul. His hope was drawn on these
pages, and his wish was that this great lady would tell him what
path he should take . . .

The whole of his life hung on the next few moments.

Flick, flick, flick, the Empress of Fashion looked at his sketches one by one. Manolo was too anxious to speak. He could hear his own heartbeat thumping louder than a symphony of kettle drums.

DRAWINGS FOR SETS.
DRAWINGS FOR COSTUMES.
DRAWINGS OF SHOES.

The Empress paused. She tapped her finger very deliberately at the page, then looked him straight in the eye and said, "Young man, do things, do accessories, do *shoes*." And with that, his audience was over. The portfolio snapped shut and he was dismissed. But as the door closed behind him, so did any doubt— it was as if fireworks had burst forth with great flashes of color and golden light. Manolo exploded with shrieks of pure joy. Every part of his being seemed to scream, "Eureka!" Inspiration was sparking everywhere.

Of course . . . SHOES!!

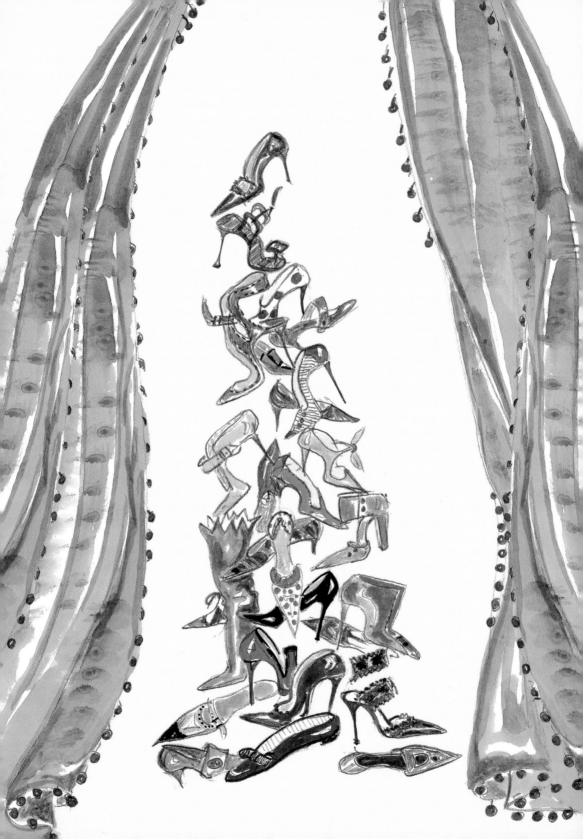

Back at the Buckles, the doorbell chimed and the rusty boot sign swung on its hinges as a *very* Grand Lady entered the old shoemaker's shop.

"I WANT TO TRY ON THOSE SHOES,"

she announced, pointing to the magical pair in the window. Mercifully, she didn't seem to even notice that this was the *only* pair in the whole store!

The old shoemaker obliged and reached for the velvet pillow. His wife helped the lady with her bags, hung her mink coat, and hurried to and fro trying to catch all the flying objects that were being hurled across the room—diamond cuffs, bangles, rings, gloves, stockings, every layer of accessory had to be removed so as not to distract from the ceremony of christening these new shoes. At last the Grand Lady had stripped any bauble, buckle, and bead that could possibly get between her and the object of her desire . . . She was ready.

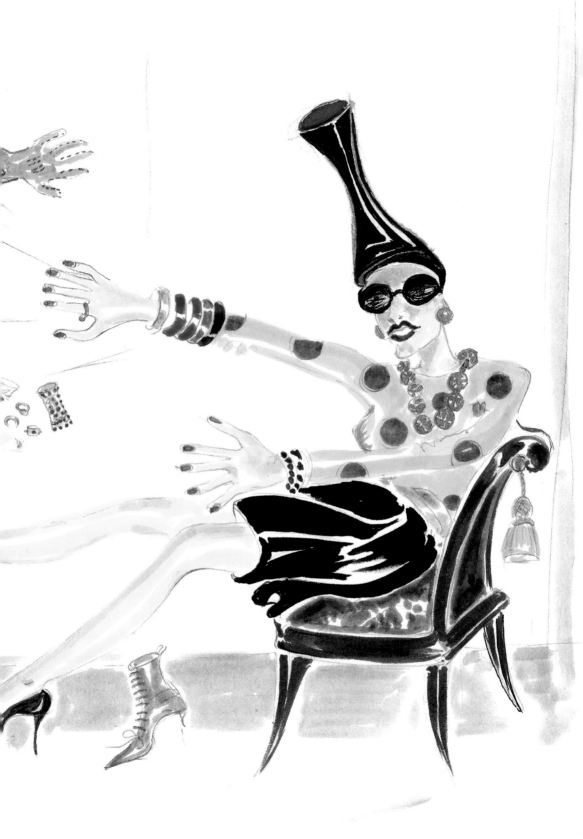

Her eyes bulged with delight and her feet practically danced as, one by one, she slipped them into the enchanting shoes.

"Darlings, I have been to all the fashion shows, all the best parties, and quite frankly I am exhausted," she said, kicking one leg excitedly over the other. "These are simply too divine, far more beautiful than anything I have ever seen.

QUESTION: WHO ARE YOU?" SHE PURRED

as she sucked, puffed, and blew a heart-shaped smoke ring up into the air from an extra-slim cigarette held firmly in place between her lithe fingers by an extra-slim, jewel-encrusted cigarette holder. The smoke ring and the question hung in the air.

She examined both the shoes and the shoemaker, through her diamanté-rimmed monocle, not at all with equal curiosity. The shoemaker coughed, loudly. He hated smoking, but the lady seemed to carry herself above "normal" rules, so, as the heart-shaped cloud hovered around his head, he kept his dislikes to himself.

"Who, indeed?" the Grand Lady said as she waved her own question away. "No matter." She snapped her handbag shut, sending a shower of cigarette ash all over the newly swept floor. The old shoemaker's wife grimaced, but even she couldn't find the voice to object.

"Good news. I have decided to take them," the woman said, not waiting or caring for their answer. "And you," she continued as she pointed her talon and cigarette in the direction of the shoemaker, "you *must* do more shoes."

And that was that. With her thoughts thus spoken, the Grand Lady stood and dropped a pouch filled with more than double the number of gold coins the old couple had set as the price for the handcrafted treasure. She then adjusted her veil and diamonds, threw her fur coat over her shoulders, and was off, lost in a bevy of assistants who seemed to appear from nowhere simply to follow in the wake of her marvelousness.

Just before she exited, she turned and handed the shoemaker her card. "I will return," she said, half-threat, half-promise, and then was gone.

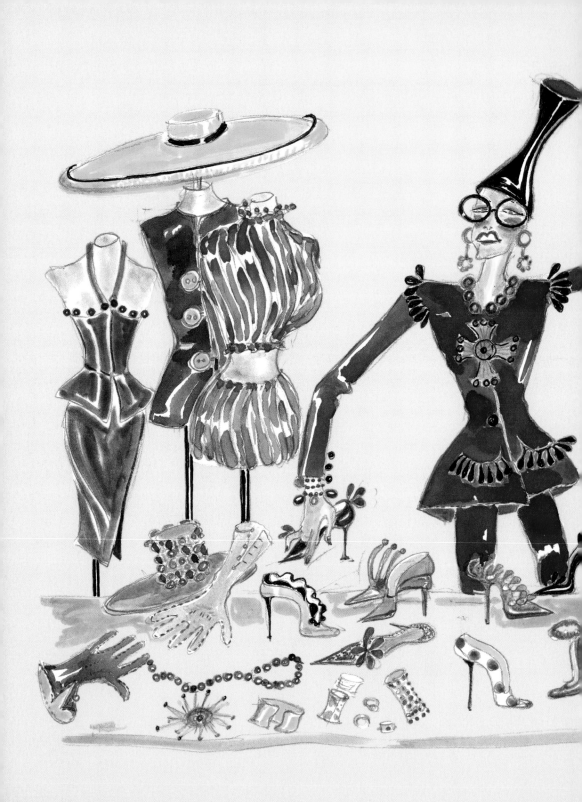

It was only after the door finally swung shut, the sign stopped swinging, and the doorbell ceased pealing with alarm, that the old couple were able to catch their breath. They turned to read the woman's card and realized for the first time that this was the all-powerful

EDITOR IN CHIEF OF *MAJESTIC MAGAZINE.*

Whatever she liked turned instantly to gold. How on earth did she find them?!

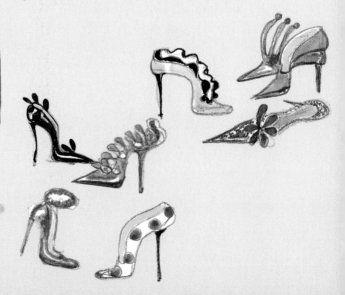

Manolo had been equally busy.

When he returned to London, he understood his destiny at last and immediately set about forging his path as a shoe designer.

SKETCH AFTER SKETCH BLITHELY DANCED FROM HIS HAND ONTO THE PAGE.

Some were met with disapproval and thrown straight into the rubbish bin, while others earned a squeal of excitement and flew instantly, like paper airplanes, to the first stop in his crazy creative production line. The myriad muses in his mind jostled for his attention, all longing to be brought to life. From Marchesas to Madames, from the *Mona Lisa* to *The Girl with a Pearl Earring,* from ladies of the Baroque period to those of the Beatnik era . . . Just like the frenzied heroine in *The Red Shoes,* now that he had started, there was no stopping him. Ideas after ideas were developed and, with much exuberance, soon realized. Fantasy danced happily into reality.

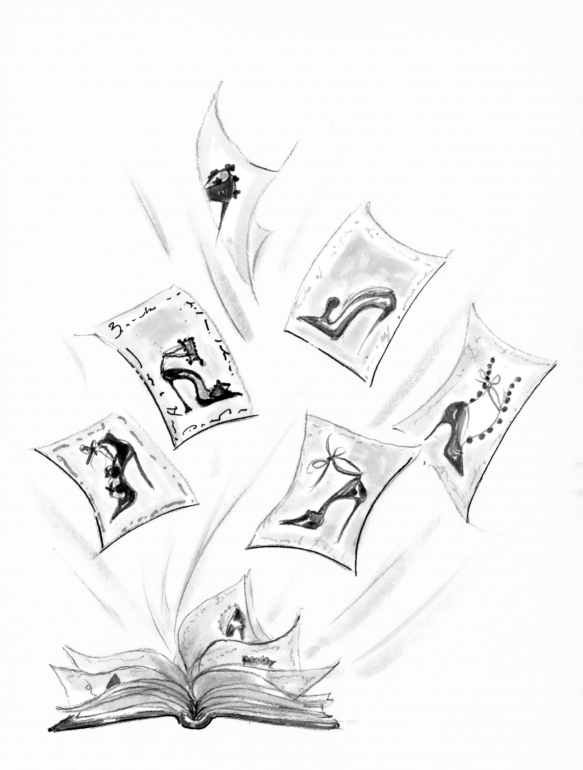

From prototype to last, from start to finish, shoemaking was indeed Manolo's true calling. Now, to prove it, he wanted to show his work to the world. Yes, he was a dreamer, but his enthusiasm was so infectious that those dreams were starting to come true, and everyone who saw his creations knew he was making magic.

WHY ELSE, DURING HIS VERY FIRST SEASON, WOULD MANOLO HAVE BEEN ASKED TO CREATE SHOES FOR ONE OF THE HOTTEST SHOWS IN TOWN?

It didn't matter that he had no prior experience in production. Why would it?! He was willing to learn, and everything he pursued thus far was done with the utmost passion.

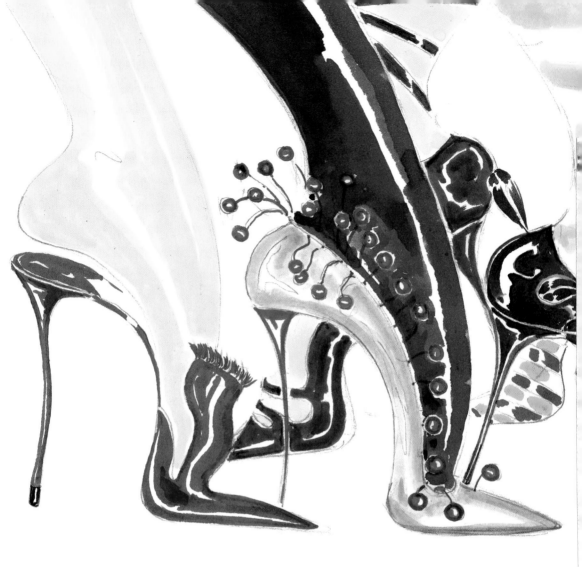

Should the heel be high? Thick or thin? Square or sharp? Green, gold, or a rich midnight blue? Manolo drew late into the night, debating all these creative quandaries with his pen and inks. Each and every part of the process enthralled and delighted him as he explored the nuances of both science and seduction. At dinner, at the dances, at any and every opportunity he could find, Manolo looked to see what the ladies were wearing on their feet and why . . .

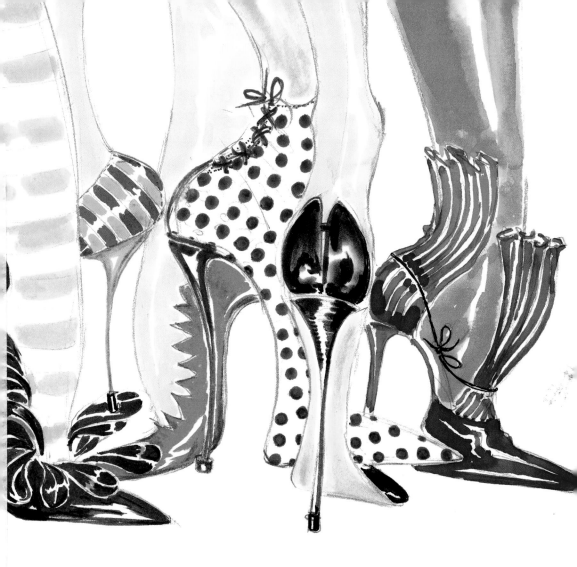

HE WANTED TO SCULPT
SERENE PERFECTION.

With his chisel and file, the artist's mission was underway.
In no time, Manolo had begun to earn a name for himself as
the shoe designer with the Midas touch.

The Buckles, too, were still reeling from their lucky twist of fate. Thanks to their surprise new patron, and their mysterious unsung hero, they were back in business.

But, instead of celebrating and foolishly squandering all the money they had just made, the old shoemaker decided wisely to invest in more fabric for more shoes. This time, though, he chose two daring shades—one a regal purple and the other a scarlet python pattern. It had been a long time since the Buckles had been in demand, so why not wow their customers? With his wife at his side to keep him company,

THE OLD SHOEMAKER CUT THE FABRIC READY FOR TWO NEWLY DESIGNED PAIRS OF SHOES.

He worked until his eyes were too weak to continue. Then the couple blew out the candles and went to bed, leaving everything neat and tidy and ready once more to complete in the morning light.

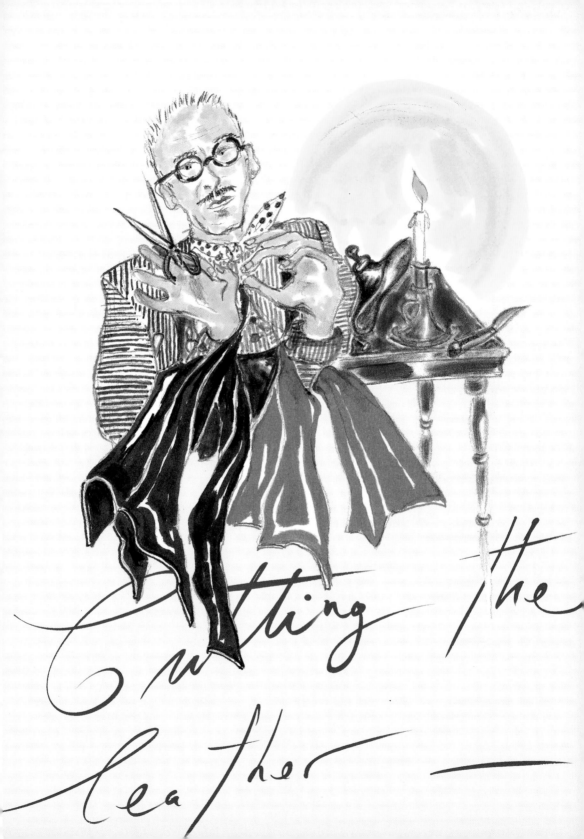

Cutting the
Leather

When the sun rose the next day, the old shoemaker bounded out of bed with far more of a spring to his step than he had had for a very long time. He slid like a child down the banister, tied on his apron, and entered his workroom.

BUT THERE, ONCE AGAIN, WAS ANOTHER MIRACLE!

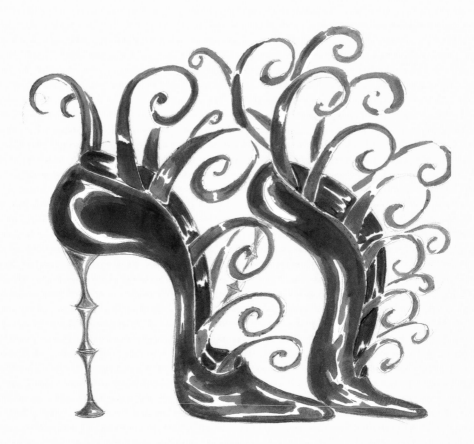

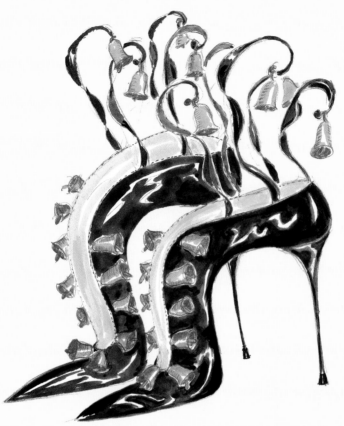

Today, two perfectly stitched pairs of shoes stood on his work bench. It seemed hard to imagine, but they were even more beautiful than yesterday's masterpieces. He couldn't believe his eyes.

Once more, his wife wasted no time placing these new creations in the window.

This time, it was only a matter of minutes before an eccentric young gentleman came in, asking to see them. He clearly loved everything about these shoes. Enraptured, he spun them on his fingers in the air as he quizzed the shoemaker about his new pet amour . . .

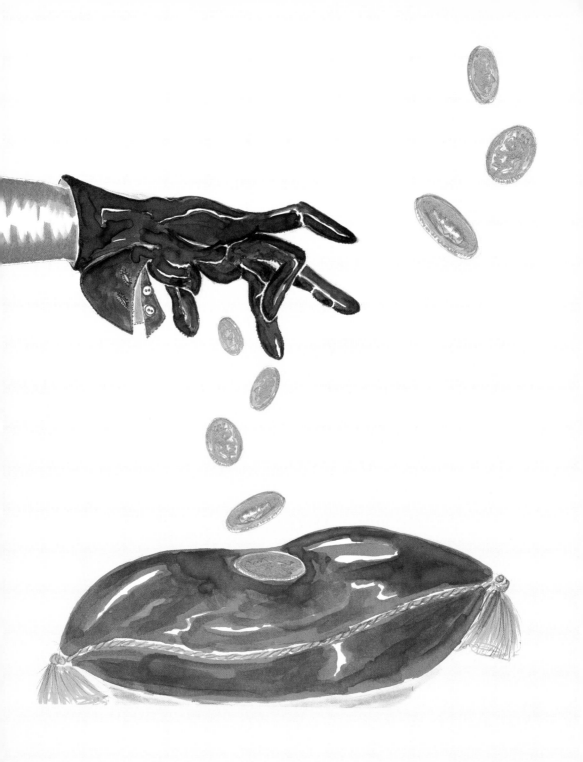

"How did you come up with these designs? Where did you find your inspiration? How ever did you get the details so perfect? Who else has seen these and who are you working with?" He gave the shoemaker no chance to reply. "No matter." He smiled, waving off any possible response.

"I AM GOING TO TAKE BOTH PAIRS," HIS SINGSONGY VOICE CHIMED.

He, too, ignored the asking price and insisted upon paying double. He didn't want anyone else to have them. He didn't even want to think about the prospect of anyone else wearing these shoes. *His* shoes. He explained that he was a very famous fashion designer, and that these were *just* the shoes needed to make his catwalk finale perfect. They were the very detail required to save the show. Several air-kisses later, he was off.

The shoemaker and his wife were once more bewildered by their good luck. What an extraordinary couple of days. But they agreed that it was still best to remain cautious. Who could blame them? Although they had seen their fortunes change, they knew what it was like to be hungry, and certainly didn't want to do anything to jinx their newfound popularity.

SO MR. BUCKLE SET OFF TO BUY MORE NEW LEATHER,

and resisted the urge to purchase a fancy new coat for his wife and the set of golf clubs he'd always dreamt of. He now had enough money to buy leather for four pairs of shoes and, though he wasn't actually doing the work, he felt confident enough to choose even wilder fabrics than those he had before . . . With the money left over, he bought Mrs. Buckle a nice bunch of flowers, their abundantly rich colors reflecting all the joy he now felt.

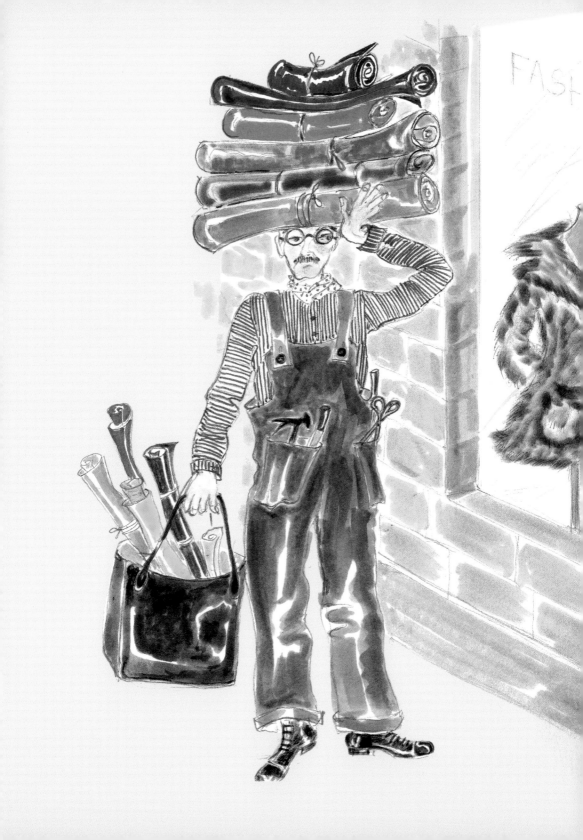

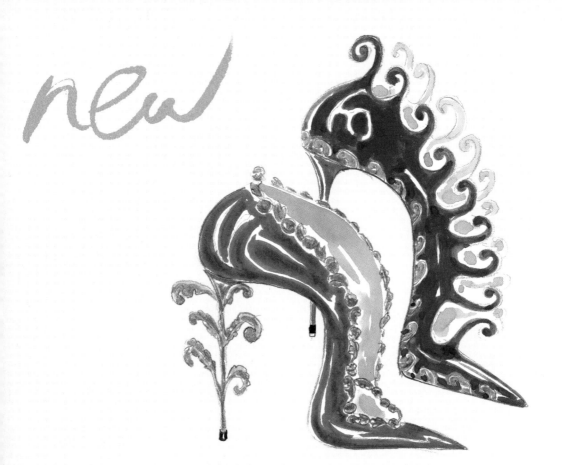

new

As usual, he worked late into the night, until his weary eyes could
see no more. He carefully determined patterns and prepared his
bench for the new shoes he would sew in the morning.

He knew magic like this only happened once in a great while,
so he certainly didn't want to become complacent or lazy—or, even
worse, to rely on it . . . The Buckles had a waiting list of new patrons
longer than his parchment could stretch, so slowing down was not
an option.

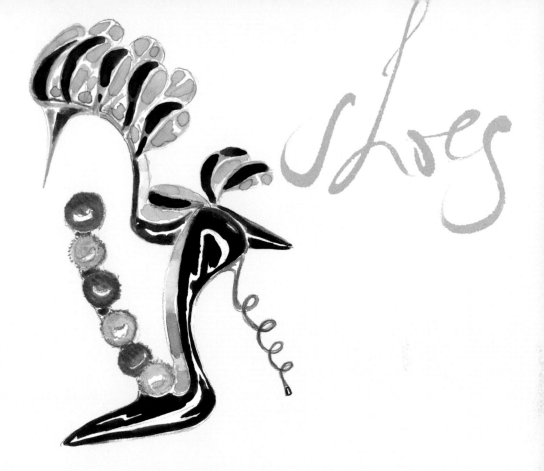

shoes

THE MAGIC HAD SAVED THEM,

and they now could sleep with a light heart, but depend on it happening each and every night, they would not.

The next day, the old shoemaker woke refreshed even though he had set his alarm extra-early. He knew four pairs would take quite a while to craft. But, once more, his intentions were rewarded. He needn't have worried, because there, on the bench, sat four perfectly stitched pairs of shoes.

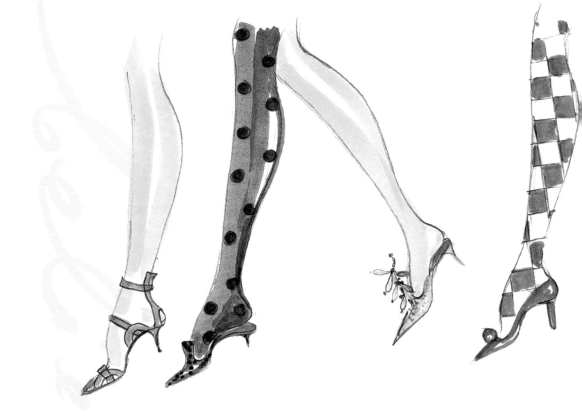

His wife didn't even have a chance to put the new shoes in the window, for a line of people had formed outside of the shop a good hour before opening. As she unlocked the door, the crowd reverently parted to make way for the returning Fashion Designer accompanied by a pouty, ethereal young girl. The designer threw his arms around the shoemaker's wife and begged her to let him have the shoes. "Forget the fickle people outside, I'm just desperate for these latest creations . . . I simply can't breathe without them," he pleaded, swooning to the floor.

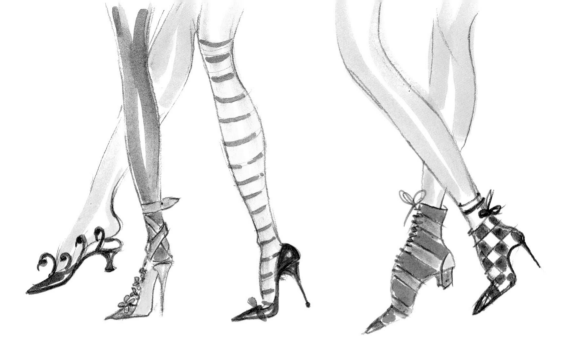

"LUCKY WON'T WALK FOR ME WITHOUT THEM."

Mrs. Buckle felt very confused by this strange new world of hysterical hyperbole, especially as she felt sure the waifish girl was totally capable of walking—all she needed was a hearty meal.

Mr. Buckle tried to hide in the back room as the theatrics continued. But it was too late; the designer had spotted him and shrieked, "Maestro," as he swept a regal bow before the old man. The shoemaker felt very uncomfortable with such adulation.

He felt a fraud. What's more, he cringed when the designer presented his wife with a gorgeous new mink and insisted that she accept it with his deepest gratitude. So generous, yet so undeserved. *However could they explain their circumstances?* Of course, the shoemaker *had* to give the designer the shoes he had requested . . . But now he had a new worry—how would they ever be able to keep up with the demand? How would they be able to produce these designs by themselves?

NO "FASHION SECRET" IS EVER A SECRET FOR LONG.

And such was true of this secret. News of these fabulous shoes spread like wildfire—especially as the Editor and the Fashion Designer who had discovered them flaunted these shoes everywhere and became the envy of the land. Everyone wanted a piece of the magic.

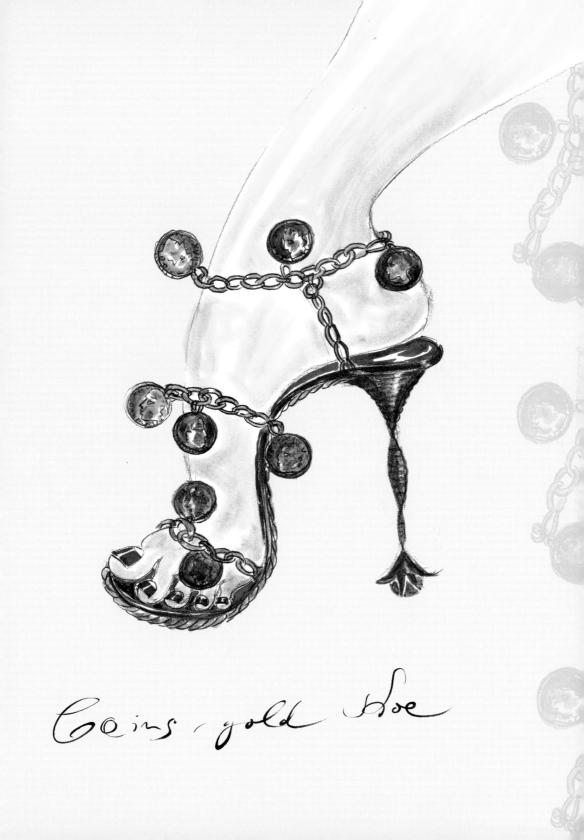

Coins gold Shoe

Somehow Mr. and Mrs. Buckle were
able to keep pace with the demand
and soon the shop was bustling,
full of life. The shoemaker and
his wife were not only busy—they
were rich, very very rich.

The magic continued, yet
throughout all the insanity,
the Buckles had not once
taken anything for granted.
Night after night, they would
carefully tidy the shop, polish
the shelves, and cut the leather
till they could work no more.

DAY AFTER DAY, THEIR DEDICATION WAS REWARDED

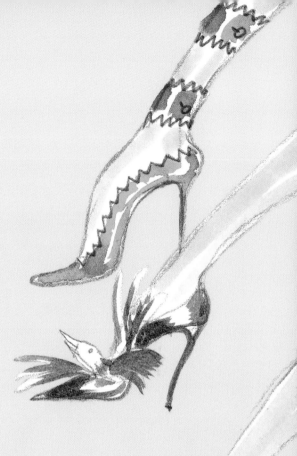

with the appearance of shoes, each pair finer than the last. *Who was responsible for this miracle?* The question of who was owed their deepest gratitude never left their minds.

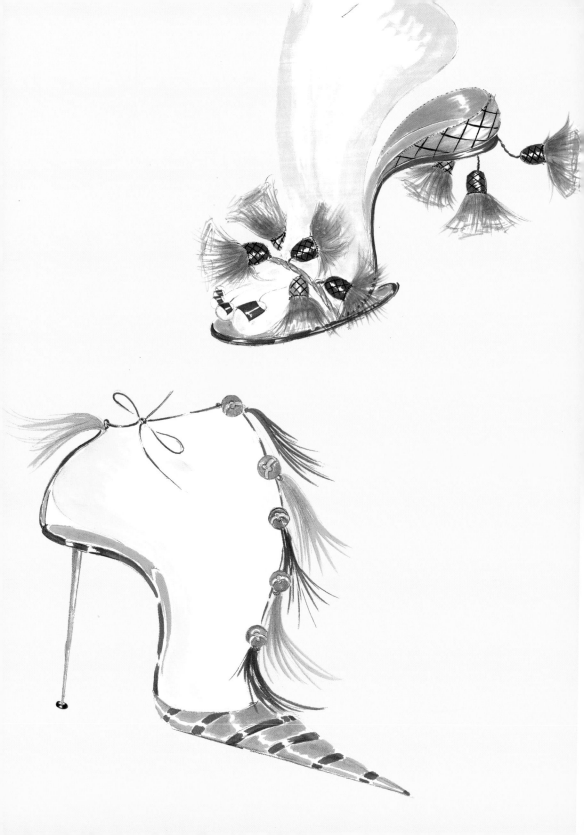

Over on the other side of town was another badly kept fashion secret . . . Tucked away in a very well-heeled corner was Manolo Blahník's very own boutique, and the only place one could find his creations. Amidst all the excitement of his anointment, he had found a factory as well as the perfect location from which to sell his designs. As he was perfecting his craft, Manolo was *also* fast gaining a cult following among the adored and iconic figures of the era.

THE VERY BEST-DRESSED WERE FREQUENTLY SPOTTED AT HIS CHICHI ADDRESS.

Manolo's passion had turned from fancy into a thriving business, yet he still managed to make dreaming up new designs seem as effortless as a tidbit of gossip making the rounds at a cocktail party. He was on the cover of magazines, in the arms of the most beautiful women in society, and, of course, on the feet of the most stylish shoe connoisseurs, too . . .

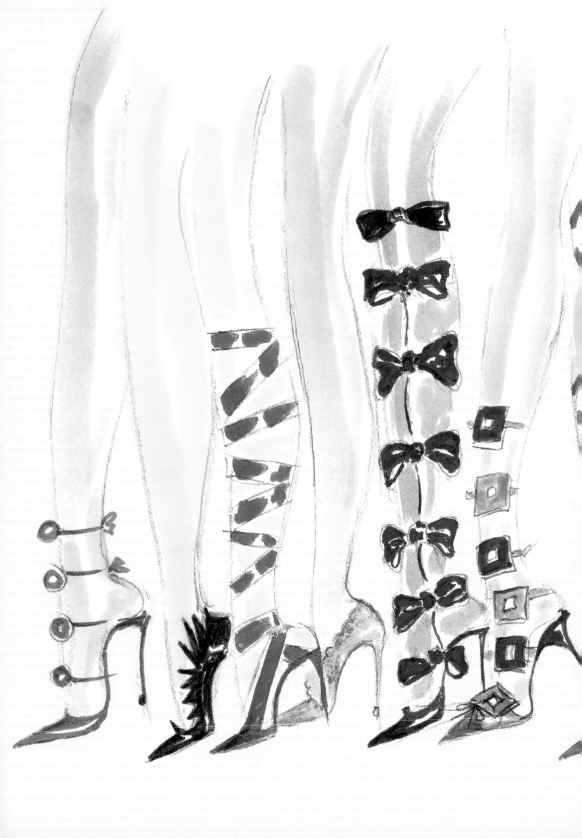

The most celebrated designers were hammering down his doors begging him to collaborate with them, yet, touchingly, it wasn't the glitz and glamour that enticed him; it was when he was creating that he felt his happiest. He thought of his designs as gestures, not as fashion . . . and

HE NEEDED AT LEAST ONE PAIR FOR EVERY MOOD, EVERY MOMENT, EVERY MANOLO.

His shoes danced lightly down the catwalks of all the greats— and soon it was generally agreed by all that if a show was worth seeing, the shoe had to be by Manolo.

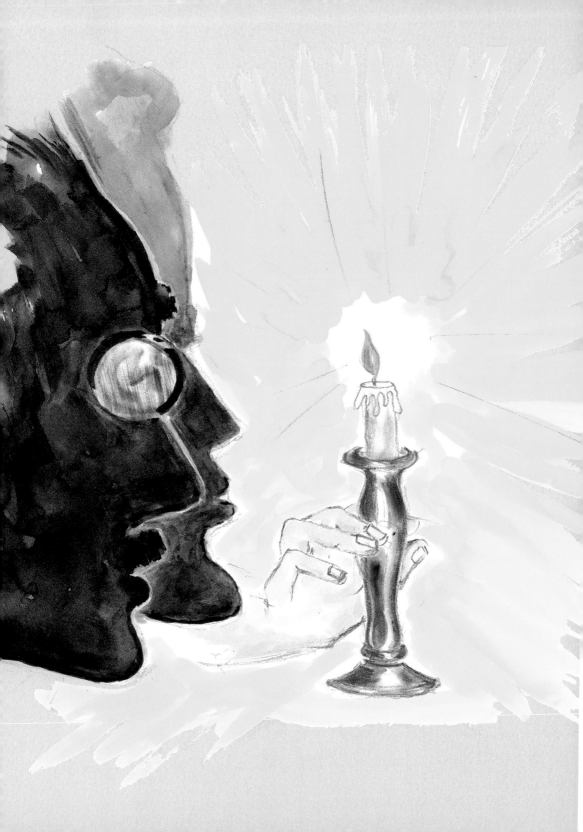

Back with the old shoemaker and his wife, there was similar hysteria. Fearing that they could no longer comfortably keep up with this charade, the time had come to find out *who* was helping them and *why*.

One evening, the shoemaker said to his wife,

"WE MUST FIND A WAY TO THANK OUR MYSTERIOUS GUARDIANS.

Let's offer them work, a job, a home, whatever it is these people desire. They have given us more than we ever dreamt of having. Surely it's the least we can do."

Mrs. Buckle agreed, and the two resolved to wait up that evening to see just *who* it was. Whoever was helping them make shoes had also helped them regain a purpose in their lives and was owed a huge debt of gratitude.

When that particular day ended, they even more carefully than usual turned the sign to

Closed

They packed up shoe boxes, put their earnings in the safe, and then busied themselves as if it were a normal evening. The old shoemaker laid out the leather. His wife fussed about the place with her feather duster and blew out all the remaining candles in the studio . . . and then it was time . . . The old shoemaker and his wife took their hiding places behind some old clothes on a coat stand in the corner and nervously waited.

When the clock struck midnight, Mr. Buckle began to yawn. His tired body was regretting this idea. Then, just as he was giving up hope, he heard the tinkle of little voices . . . Out from the skirting board came two little shadows and then, ever so quietly, the mystery promised to be solved . . .

TWO TINY ELVES APPEARED, DRESSED IN RAGS.

They jumped onto the workbench, examined the leather and ideas left in place, and merrily started dancing, sewing, and hammering. They moved so briskly that the shoemaker and his wife didn't dare blink. Mr. and Mrs. Buckle watched as their helpers stitched patterns caught on the breeze and made light work of the old man's heavy duty. And when the elves' work was finally done, they vanished without even a backward glance.

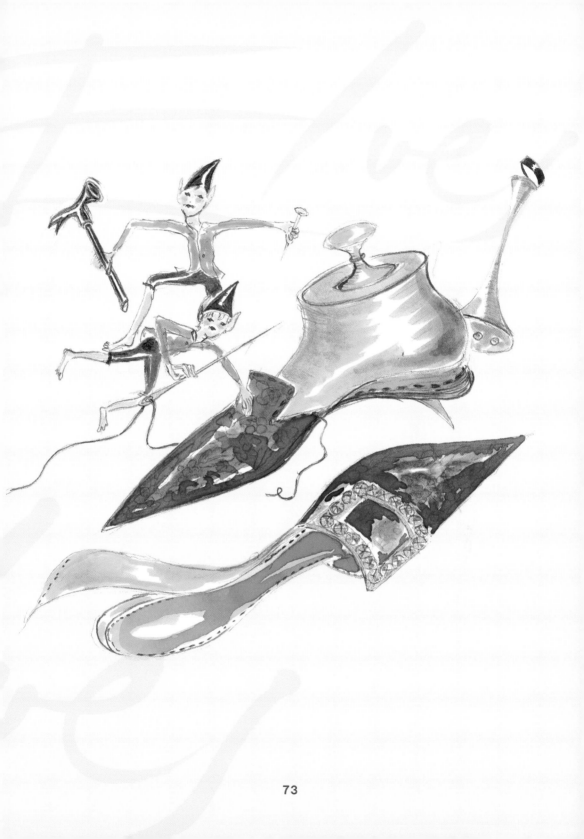

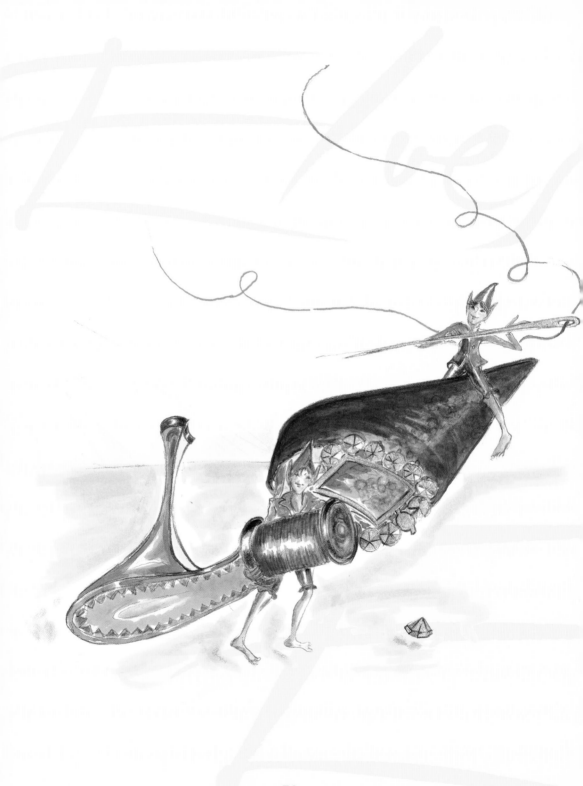

The old shoemaker and his wife were speechless. They dared not believe their eyes.

But, the next morning, the shoemaker examined the shoes, and once again could find no fault with them, or indeed the jolly little sprites who had whipped up these creations and brought them to life. His wife had been thinking all night and at last broke the silence.

"I'VE GOT IT!"

she exclaimed. "I know what we can do to show them our thanks. Let's make *them* new shoes and stitch some new clothes of their own, too!"

And so, this is what they did.

Each evening, they would close up the bustling shop, shoo away the last of their fawning clients, and, after their chores, the shoemaker would secretly work with the softest leather to cut and craft the tiniest shoes you have ever seen. In doing so,

HE REALIZED JUST HOW MUCH PRIDE HE TOOK IN HIS WORK AND HOW MUCH HE MISSED BEING CREATIVE.

He hummed happily as his wife sewed alongside him, busily making two tiny white shirts, two itsy-bitsy pairs of pants, and two smart yet super-small red jackets to match the beautiful shoes. She even made two little caps with a feather trim and two pairs of tiny, lovingly darned white socks. And on that eve, the Buckles' secret labor of love was finally complete.

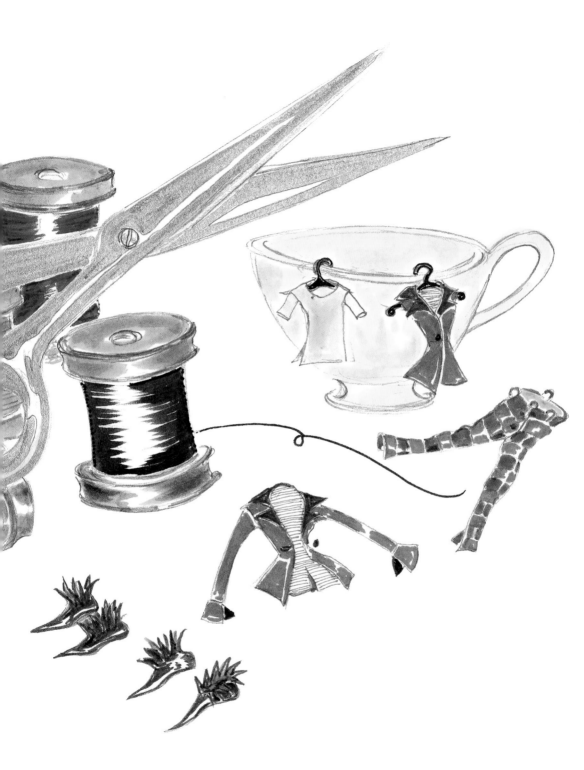

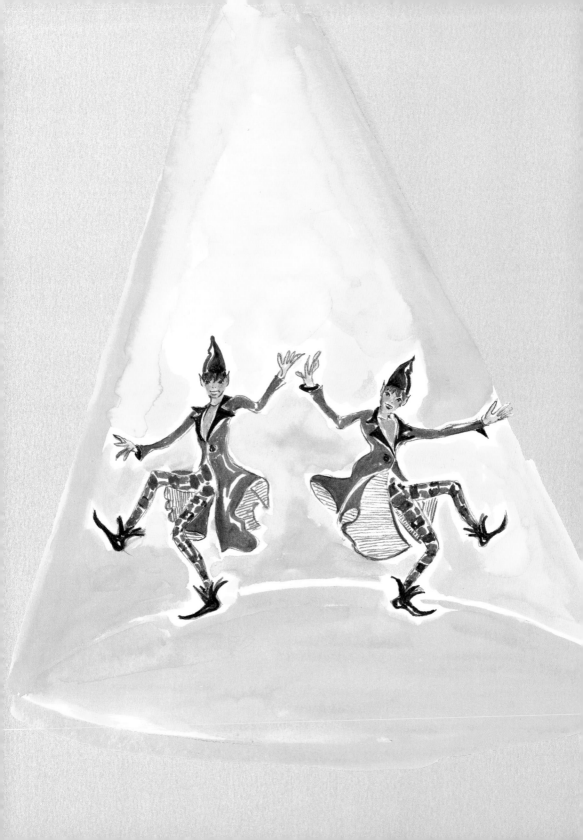

That night, the old shoemaker cleared the leather and tools from his workbench and, instead of laying out the usual patterns, he and his wife carefully laid out the new clothes and shoes.

They filled two thimbles full of ale and also left a hearty mince pie. Then they blew out all the candles, hid, as they had done before, and waited to see how the elves would react.

JUST AS THE CLOCK STRUCK MIDNIGHT, THE ELVES CREPT IN—THEIR FEET BLUE WITH THE COLD.

They jumped on the bench ready to work . . . but instead of their labors found food, drink, and tiny clothes. They whooped and hollered with delight! They could not believe it. No one was ever nice to elves! The pair danced and laughed. In no time, they had changed out of their rags and into their lovely new raiments. They jumped all around the studio, getting merrier and merrier with every sip from their thimbles. They sang for joy, as this was their first night off since their elfdom began. "Now you see, so fine are we, we need no longer cobblers be!"

As the continuing lyrics to their song ultimately revealed, the two brother elves had once been the most idle, greedy, good-for-nothing layabouts you can imagine. Their father was so enraged by their behavior, he had cast a spell to teach them a lesson and the pair were bound by magic to work, without rest, for every kind, exhausted soul that had ever lost their inspiration.

THEY HAD TO BE MASTERS OF EVERY TRADE, YET GET THE CREDIT FOR NONE.

They had to work in secrecy and with dedication and good humor, too, even though they were shrunk to the size of a human thumb. Only when they had earned praise and gratitude for a thankless task well done, would the two brothers at last be free . . .

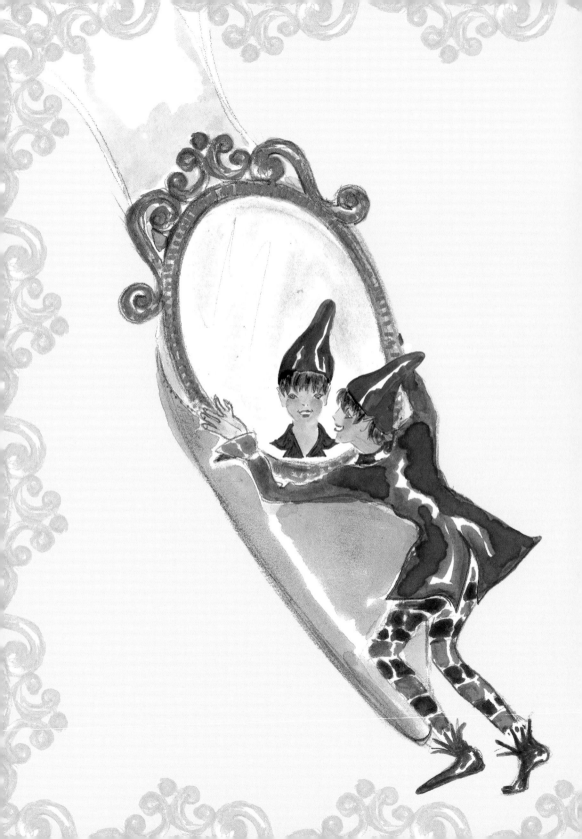

They had toiled for years and never once were their good deeds rewarded. It appears that no one ever thinks to thank magic and lucky twists of fate for the fortune they bring. The elves had hopped from worthy cause to worthy cause, thinking that being downtrodden heroes was a surefire way to secure their freedom. But it wasn't until they had stopped thinking of themselves and applied their skills with selfless determination to help the old shoemaker that their path became clear and, more importantly, enjoyable.

NOW THAT THE OLD SHOEMAKER WAS A SUCCESS, THEIR EFFORTS SEEMED WORTHWHILE.

They had returned night after night simply to see the delight and sense of hope reappear on the old couple's faces. Yes, this had been a good job well done. They laughed as they admired their reflections in the silver buckle of a finely crafted court shoe that the shoemaker's wife had positioned carefully on the desk. They could see that at last they were men their father would be proud of.

"We're free!" cried the smaller of the two elves. Out from the pockets of his rags, he threw scrunched-up paper sketches into the air, like confetti. "And we have Manolo to thank!"

The shoemaker and his wife exchanged confused glances.

"Shhh!" warned the other elf.

"Why? It's not like we were stealing," replied the delirious one.

"MANOLO THREW THESE SKETCHES INTO THE RUBBISH

WHEN HE WAS A CHILD . . ."

"True, but we knew long, long before he ever did that he would become the greatest shoemaker that there ever was . . ."

"Well, how else could we have broken the spell?" replied his brother. "It's not cheating, is it? Sometimes you have to work to achieve your goal . . . Sometimes the good ideas are put right in front of you. Nobody knows that better than us!"

With the ring of truth to this reasoning, the two linked arms and raised their thimbles in one final toast.

"To Manolo!" they cheered.

"Manolo?" the wife mouthed to her husband. He simply shrugged and watched as the merriment continued.

The giddy brothers sang as they zigzagged out the door:

Manolo, Manolo,
wait and see,
you'll the greatest cobbler be!

With this song our task is
done, but your career has
just begun!

With childhood ideas
thrown away
we helped this cobbler
seize the day.

Hereby for your magic touch
We grant you always much
luck, love, joy, and such!

The elves' singing got wilder and wilder as they danced out into the night, blowing kisses to all corners of the earth. With each and every step they took they grew taller and taller, until, when they finally reached the horizon, they had grown to be the full-fledged men their father would welcome back home.

The old shoemaker and his wife knew they would never see the little fellows again. Their job was done, and they were truly glad.

The next morning, the Buckles awoke and found the workbench littered with the miniature sketches left from the merriment and magic of the night before.

THE OLD SHOEMAKER LOVINGLY SMOOTHED EACH OF THEM OUT, AND HIS WIFE GINGERLY GAVE THEM A DELICATE IRONING.

Then they wrapped them up in a big parcel, as if they were handling the crown jewels, and returned them, with a note, to their rightful owner.

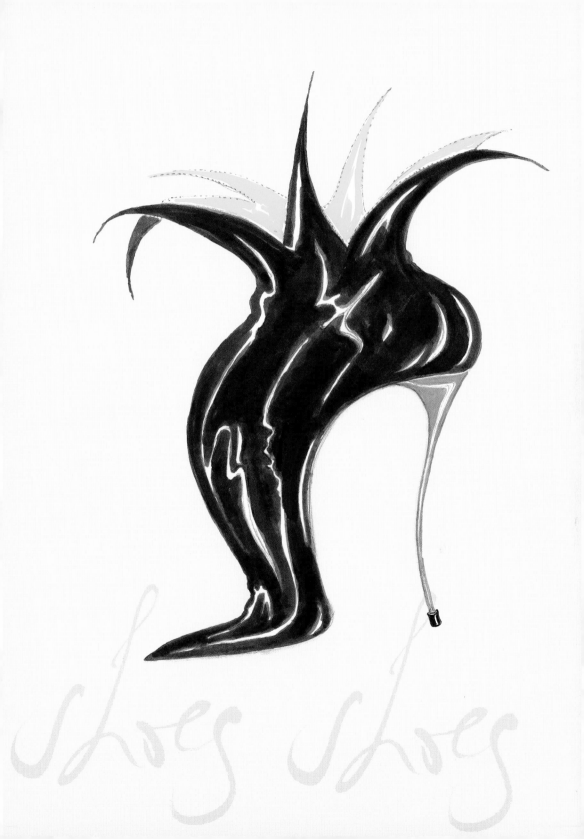

Manolo's shop was bustling as usual when the doorbell rang. A battered package bearing his name in purple ink had arrived, but he did not recognize the postmark. *Perhaps it's an exotic invitation to another Fashion Week gala?* he mused.

Manolo was mid-season, juggling his own collection along with those of several designers, so he was understandably preoccupied. But he quickly forgot all of that when long-lost childhood drawings fell out from the now-open parcel.

HOW COULD THIS BE?

They were ideas tossed into the bin long ago, when I was just a child making shoes for my menagerie of friends.

Why are they now as small as postage stamps?

Despite all of his questions, Manolo couldn't help but smile at all the memories these images stirred. What good fortune could have brought them back to him?

There was a note folded politely in two, written in the same slodgy handwriting that had addressed the outer package. Manolo sat down to read it straight through. Time would stand still as he took in the most extraordinary tale the letter told.

HIS SKETCHES HAD BEEN ON QUITE A JOURNEY.

The old shoemaker and his wife explained who they were, and how their business had been transformed by magic from bust to boom. How, each morning, they would find shoes in their workroom, and how they had no idea who was helping them or why. They explained, also, how one night they had spied two elves laboring away. How, in order

to thank the elves,
they had fashioned
them brand-new
tiny clothes and shoes,
and how the elves danced
out of their rags and produced
these tiny sketches from their
pockets, sprinkling them like
glitter everywhere while toasting
Manolo's fine name.

They didn't really understand
all that had happened, or how
the elves had come upon his
drawings, but they thought he
would want them back.

Manolo was astounded.

The shoemaker and his wife confessed that they did not have the energy of the elves, or the inclination, to deal with this strange new industry that had adopted them. They also had no intention of taking credit for ideas they suspected were his.

ONLY MANOLO DESERVED THE PRAISE.

Only Manolo should execute and create these shoes, this magic, this desire . . . Besides, they had been inspired—thanks to him and the elves—at last, to follow their own dreams. They had always worked hard, and done what was expected of them, but they really didn't want to be shoemakers anymore. They had made amends with their son, a banker, and he was joining them in their new venture. They were going to open a mail-order company featuring their line of elf clothing, and they wanted to spend their remaining days doing good for other do-gooders in the magic community.

From that day forward, the old shoemaker and his wife never created anything bigger than an apple, but

THEY WERE HAPPY AND CONTINUOUSLY BLESSED

with good fortune and ideas for all of their days.

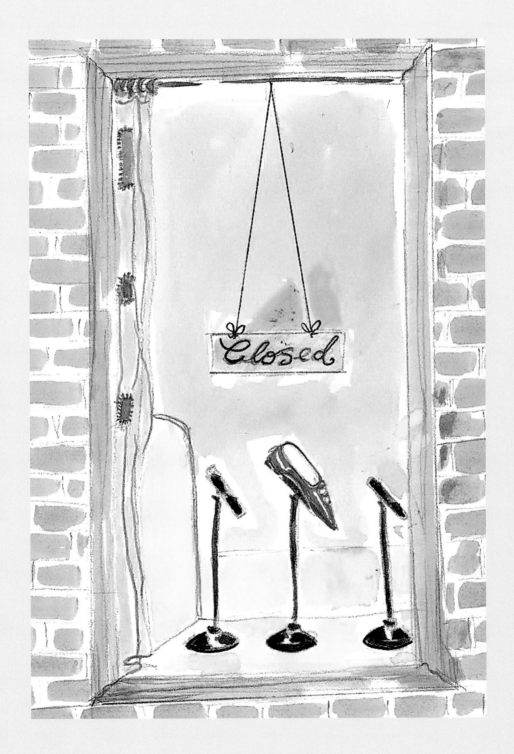

and the

Manolo never forgot their story, and, as a man of
his word, honored their request.

HE CREATED DREAMS,

desires, and shoes, so every maiden who came to his door
could walk away happily-ever-after just as her heart
desired.

Shoemaker —

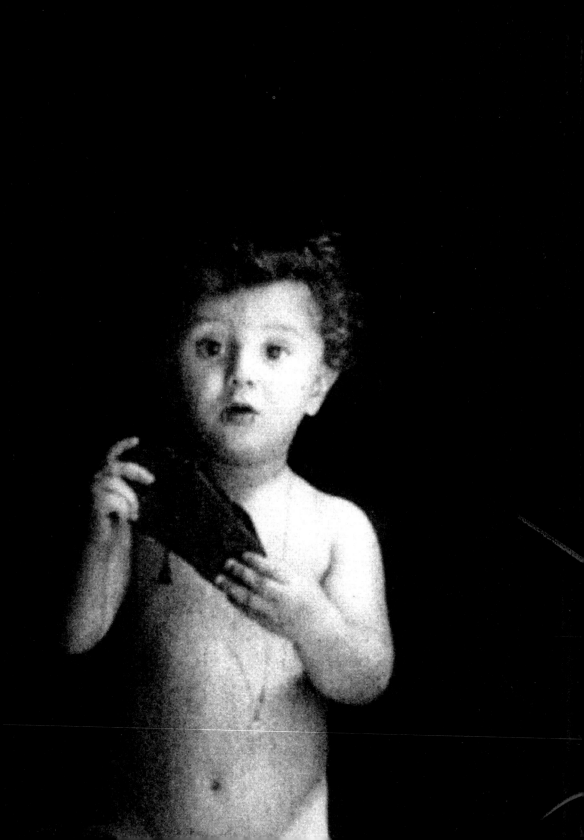

MANOLO BLAHNÍK
Time Line

1942 Manolo Blahník is born in the Canary Islands to a Spanish
mother and a Czech father. He spends his childhood there and
is educated at home on the family's banana plantation.

1961 Travels to Geneva initially to study international law, but soon
changes to study international literature, languages, and art.

1965 Moves to Paris to study art.

1969 After moving to London, Blahník works as a buyer in a fashion
boutique, writes for *L'Uomo Vogue,* and becomes part of the
London art scene. He hopes to emulate Cecil Beaton, Oliver
Messel, and Rex Whistler by becoming a set designer.

1970 In New York, he meets Diana Vreeland, in her last year as
editor-in-chief of U.S. *Vogue.* Seeing his drawings, she
admires his shoe sketches and advises him to concentrate
on designing footwear. He follows her advice and starts
designing shoes.

1972	Creates shoes for fashion designer Ossie Clark's runway show. Designs shoes for other London fashion designers like Jean Muir and Zandra Rhodes.
1973	Opens a small boutique on Old Church Street in Chelsea. Develops his craft by working with craftsmen at the Turner Brothers footwear factory in Walthamstow, North East London.
1974	Manolo Blahník is the first man to be featured on the cover of U.K. *Vogue,* with Anjelica Huston in a photograph by David Bailey.
1977	Manolo Blahník's shoes are sold in America for the first time, through Bloomingdales.
1979	The first U.S. Manolo Blahník boutique opens on Madison Avenue.
1980	Manolo Blahník designs shoes for American fashion designer Perry Ellis. Throughout the 1980s, Blahník collaborates with several British designers, most notably Rifat Ozbek.
1984	Develops a collection of shoes for American fashion designer Calvin Klein.
1988	Starts a collaboration with Isaac Mizrahi that lasts several seasons.

1990	Over the next number of years, he collaborates with British designers, including John Galliano.
1994	Works with several of New York's top designers—Bill Blass, Carolina Herrera, and Oscar de la Renta.
1997	Collaborates with John Galliano on his first haute couture collection for Christian Dior in Paris.
2000	Fashion historian Colin McDowell writes *Manolo Blahník*, published by Cassell & Co.
2002	Collaborates with American designers Zac Posen and Proenza Schouler.
2003	The Design Museum in London opens "Manolo Blahník: Shoes," a retrospective of thirty years of shoe design. Thames & Hudson publishes *Manolo Blahník: Drawings*.
2005	Thames & Hudson publishes *Blahník by Boman: A Photographic Conversation*.
2006	Designs a collection of shoes that features in *Marie Antoinette*, a film by Sofia Coppola.
2006	Collaborates with U.K. designers Christopher Kane and Aquascutum.

2007 Manolo Blahník receives an honorary CBE from Her Majesty Queen Elizabeth II in recognition of his status as one of the most successful and influential designers of our time.

2008 Manolo Blahník presented with the Rodeo Walk of Style award in the U.S.

2010 Manolo launches a pop-up shop at Liberty of London.

2010 Manolo publishes a second book of drawings with Thames and Hudson.

2011 Manolo receives the SCAD (Savannah College of Art and Design) André Leon Talley Lifetime Achievement Award.

Acknowledgments

Thanks to the wonderful team at Manolo Blahník: most especially to Richard Falzon for all his help with this project, Manolo's family and extended family, fashion editors, friends, and the artisans and manufacturers who bring the drawings to life.

Most of all thanks to the maestro himself, Manolo, whose dear friendship and footwear has kept this Cinderella enchanted for years. I hope this book does your creations and kindness justice.

Thank you to Carrie, Hope, Lorie, Joseph, Cal, Andrea, Joe, and all at HarperCollins and It! Books for allowing the magic to continue and producing such a beautiful book . . .

To my friends and family and all those who witnessed all the insanity and fantasy that makes fairy tales and fashion reality and said keep going . . .

To all those who have supported, bought, and enjoyed this book, to those who believe in happily ever afters, thank you.

FIRST EDITION

Designed by Lorie Pagnozzi with Camilla Morton

Library of Congress Cataloging-in-Publication Data has been appplied for.

ISBN 978-0-06-191730-1

11 12 13 14 15 ID5/RRD 10 9 8 7 6 5 4 3 2 1